Introduction

The art forms known as Baroque were a product of a period spanning the seventeenth century and the early decades of the eighteenth century. Geographically, they were employed over most of Europe and Latin America, where their development and decline followed an irregular pattern from one country to another. Their local characteristics were likewise very varied, despite a common origin; and so too was their popularity.

The reasons for these differences were both geographical and historical. The Baroque grew up at the beginning of the seventeenth century in papal Rome, where, rather than a clearly defined style, it was a tendency, common to all the arts – in short, it was a taste, a fashion. Later it spread to the rest of Europe and to Latin America, the typical Baroque forms appearing in these parts of the world after an interval that increased with their distance from Italy. Thus Italy, while still in the forefront of artistic development in Europe at the beginning of the Baroque period, by the end of it had lost its artistic supremacy, which had passed to France, where it was to remain. By approaching the subject from its Roman beginnings, however, we can grasp its essential unity.

This wave of influence did not move out from Italy into a void: instead it encountered, and fused with, local tendencies and schools. In this way many art forms of a national character were produced, each with its own peculiarities; and it was these varying and various art forms that together constituted Baroque art. The results achieved in architecture, painting, and other disciplines were in no way inferior to their Italian counterparts. In some fields, in painting, for example – and it is enough to name Rubens, Rembrandt, and Velázquez – they were clearly superior.

As far as theoretical concepts are concerned, the

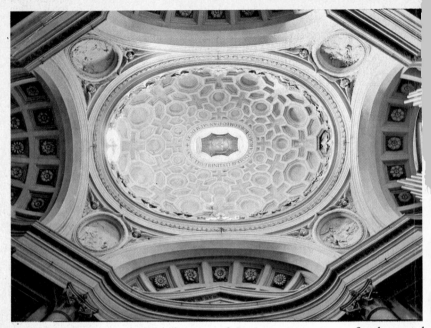

▲ Complex buildings with complex embellishments: such, in a few words, is Baroque architecture, and no one brought this out better than Borromini. The Church of S. Carlo alle Quattro Fontane, in Rome, is small, almost a chapel, but the walls undulate throughout in a complicated series of convex and concave curves. Above this base rises not a round but an elliptical dome, a shape very much less easy to construct.

essential feature of Baroque art was a fundamental ambiguity. Baroque artists proclaimed themselves the heirs of the Renaissance and claimed to accept its norms, but they violated these systematically both in the spirit and in the letter. Renaissance meant equilibrium, moderation, sobriety, reason, logic: Baroque meant movement, desire for novelty, love of the infinite and the non-finite, of contrasts and the bold fusion of all forms of art. It was as dramatic, exuberant, and theatrical as the preceding period had been serene and restrained.

Indeed the two movements had quite different objectives; and so the means used to attain them were also different, even directly opposed. Renaissance art addressed itself to reason and above all sought to convince: Baroque art, on the other hand, appealed to instinct, to the senses, the imagination, and sought to captivate. It was not without effect that it came into being as the artistic instrument of the Catholic Church, bent at that time on winning back heretics or at least on consolidating the faith of believers and impressing them with its own majesty, to which end several elements of the Baroque, in various forms, were conspicuously apt.

▶ The Baroque age was fertile in invention and achievement in the fields of town-planning and garden design. Its highest expression, in the latter, was probably found in the royal palaces built for Louis XIV outside Paris, as, here, at Marly, and at Versailles and Fontainebleau. In the seventeenth century, the 'French' garden replaced the 'Italian' garden which had been fashionable during the Renaissance. This new style occupied a far greater area, the arrangement being basically of long, straight avenues converging on circular open spaces with broad expanses of water.

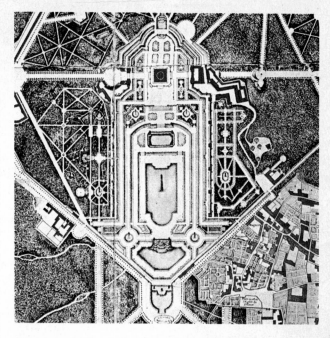

▼ In the gardens, Versailles. Sculpture was often merged with architecture, united by the combined taste for dynamic movement, brilliant colour, and fantastic effects.

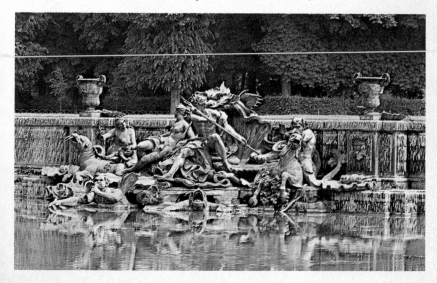

Architecture

It was characteristic of Baroque architecture that, though examples are to be found almost throughout Europe and Latin America, they differ notably from one country to another. How is it, then, that they are all designated by a single term? Partly for convenience, in order to summarize the art of a whole period with a single word, but mainly on account of their common aesthetic origin.

In Spain the term 'Baroque' originally denoted an irregular, oddly-shaped pearl, whereas in Italy it meant a pedantic, contorted argument of little dialectic value. It ended by becoming, in almost all European languages, a synonym for the extravagant, deformed, abnormal, unusual, absurd, and irregular; and in this sense it was adopted by eighteenth-century critics to apply to the art

▶ In almost all Baroque churches, the centre of the façade was given greater importance than the sides. There were many ways of achieving this, usually by making it higher and by grouping the architectural elements, the portals, groups of columns, and so on, around it. In S. Andrea al Quirinale, in Rome, Bernini established his desired effect by placing before the façade an elegant, semicircular portico, crowned with a decorative coat-of-arms. This feature demonstrates the Baroque feeling for curving lines as an inspiration of architectural movement.

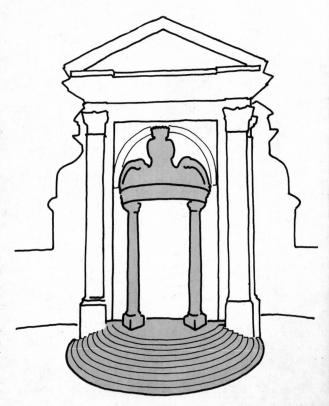

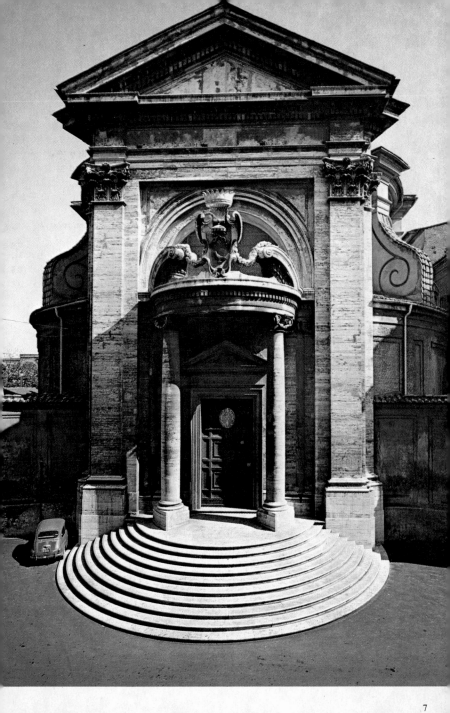

▶ Baroque architecture neither repudiated nor abandoned the traditional classical forms — columns, arches, pediments, friezes, etc. — but transformed them in imaginative and idiosyncratic ways. No one went further in this direction than Borromini. For example, pediments above windows, doors and buildings themselves are normally triangular or semicircular; but here they are interrupted (as over the central portal), or mixtilinear, combining curved and angular lines. Some have their proper function inverted and are placed below instead of above the window. It was this sort of treatment that, in the eighteenth century, was to provoke accusations of absurdity and extravagance against the Baroque.

of the preceding century, which had seemed to them conspicuously to possess such characteristics.

In the second half of the nineteenth century the Swiss critic Heinrich Wölfflin and his followers gave the word a more objective meaning. Still referring to the art of the seventeenth and early eighteenth centuries, they defined as Baroque those works in which certain specific characteristics were to be seen: the use of movement, whether actual (a curving wall, a fountain with jets of water forever changing shape) or implied (a figure portrayed as making a vigorous action or effort); the attempt to represent or suggest infinity (an avenue which stretched to the horizon, a fresco giving the illusion of a boundless sky, a trick of mirrors which altered perspectives and made them unrecognizable); the importance given to light and its effects in the conception of a work of art and in the final impact it created; the taste for theatrical, grandiose, scenographic effects; and the tendency to disregard the boundaries between the various forms of art and to mix together architecture, painting, sculpture, and so on.

In architecture two types of building most occupied the

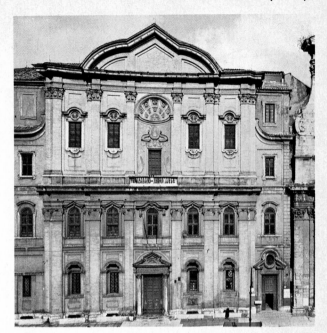

► Façade of the Oratory of St Philip Neri, in Rome. Apart from the capriciousness of the detail, the façade of the Oratory is also typical of the Baroque in its dynamic movement. The lower storey bulges and curves outwards in the centre, while the upper one curves inward, forming a recess. This contrary movement provides the room for a small balcony which, together with other details, emphasizes the central bay. Here the same effect as at S. Andrea al Quirinale is obtained, but by quite different means.

attention of the age: the church and the palace. In their different versions they respectively included cathedrals, parish churches, and monastic buildings, and town and country mansions, and above all royal palaces, these last being especially typical of the period. In addition to such individual buildings, Baroque architecture was also characterized by what is now known as town-planning, then entering upon its history: the arrangement of cities according to predetermined schemes, and the creation of great parks and gardens around residences of importance.

A building can be conceived of in many different ways: as an assemblage of superimposed storeys (the present attitude); as a box defined by walls of regular shape (as Renaissance architects understood it); or as a skeletal structure, that is, one formed – according to the Gothic conception – by the various structures needed to sustain it. Baroque architects understood it as a single mass to be shaped according to a number of requirements. A verbal description of Renaissance forms might be accompanied by the drawing of imaginary straight lines in the air with an imaginary pencil; but a man describing the

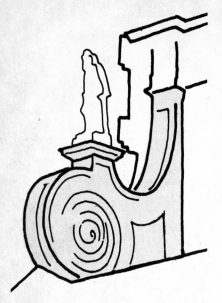

◀ ▲ Two features here are typical: the great scrolls, which provide an organic link between the wide base and the narrower dome which they help to support; and the integrated silhouette to which they contribute.

Baroque is more apt to mime the shaping out of an imaginary mass of soft plastic or clay. In short, for Baroque architects a building was to some extent a kind of large sculpture.

This conception had a cardinal effect on the ground-plan – the outlines of the building as seen from above – that came to be adopted. It led to the rejection of the simple, elementary, analytical plans which were – deliberately – preferred by Renaissance architects. Their place was taken by complex, rich, dynamic designs, more appropriate to constructions which were no longer thought of as 'built', or created by the union of various parts each with its own autonomy, but rather as hollowed out, shaped from a compact mass by a series of demarcations of contour. The ground-plans common to the architecture of the Renaissance were the square, the circle, and the Greek cross – a cross, that is, with equal arms. Those typical of Baroque architecture were the ellipse or the oval, or far more complex schemes derived from complicated geometrical figures. Francesco Castelli, better known by the name he adopted for himself, Borromini, designed a church with a ground-plan in the shape of a bee, in honour of the patron who commissioned

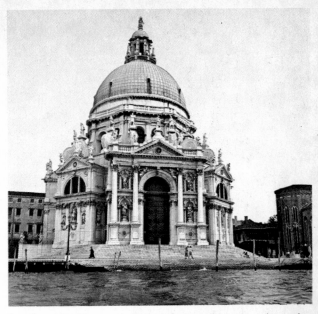

▲ On Baldassare Longhena's Santa Maria della Salute, in Venice, the great scroll-buttresses — the 'ears' — which are among the principal features of the exterior exemplify one of the most widespread elements of Baroque architecture. They provide a brilliant solution to the problem of giving a classical appearance to the buttresses that are required by every vaulted roof.

MOVEMENT ON WALLS.

it, whose family coat-of-arms featured bees; and another with walls that were throughout alternately convex and concave. One French architect went so far as to put forward ground-plans for a series of churches forming the letters which composed the name of his king, LOUIS LE GRAND, as the Sun-King Louis XIV liked to be called.

Besides their complex ground-plans, the resultant curving walls were, therefore, the other outstanding characteristic of Baroque buildings. Not only did they accord with the conception of a building as a single entity, but they also introduced another constant of the Baroque, the idea of movement, into architecture, by its very nature the most static of all the arts. And indeed, once discovered, the undulating motif was not confined to walls. The idea of giving movement to an architectural element in the form of more or less regular curves and counter-curves became a dominant motif of all Baroque art. Interiors were made to curve – from the Church of S. Andrea al Quirinale by Gian Lorenzo Bernini, one of the main creators and exponents of Roman Baroque, to that of S. Carlo alle Quattro Fontane or S. Ivo alla Sapienza by Borromini, his closest rival. So too were

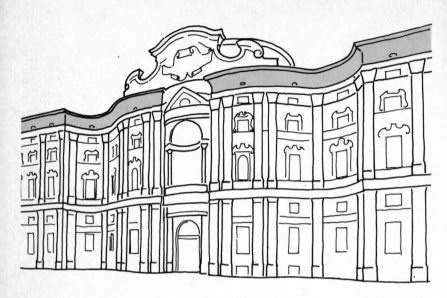

▲ Baroque architects readily sought the effect of movement, which they achieved by shaping the walls of their buildings as though they were giant sculptures rather than 'stone boxes'. Thus the curving façade became one of the motifs of Baroque architecture, especially in Italy. Here, the curvilinear façade also features the customary predominance of the centre, which is made to stand out from the rest of the building by the two curving recesses on either side.

façades, as in almost all Borromini's work, in Bernini's plans for the Palais du Louvre in Paris, and typically in the work of Italian, Austrian, and German architects. Even columns were designed to undulate. Those of Bernini's great *baldacchino* in the centre of St Peter's in Rome were only the first of a host of spiral columns to be placed in Baroque churches. The Italian architect Guarino Guarini actually evolved, and put to use in some of his buildings, an 'Undulating order', in the form of a complete system of bases, columns, and entablatures distinguished by continuous curves.

Even excepting such extremes, during the Baroque period the taste for curves was nonetheless marked, and found further expression in the frequent use of devices including volutes, scrolls, and above all, 'ears' – architectural and ornamental elements in the form of a ribbon curling round at the ends, which were used to form a harmonious join between two points at different levels. This device was adopted primarily as a feature of church façades, where they were used so regularly as to be now perhaps the readiest way of identifying a Baroque exterior. In spite of their bizarre shape their

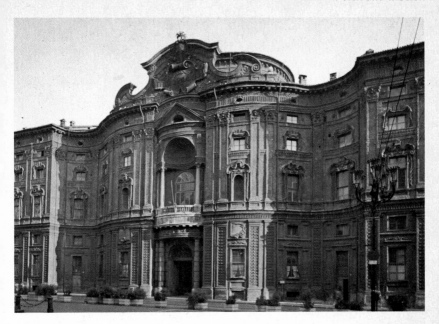

▲ In Guarino Guarini's Palazzo Carignano, in Turin, the convex centre encloses the main staircase or, indeed, staircases – a Baroque innovation, since no earlier period had given preeminence to a practical feature. The windows and doors of the brick façade are embellished with a form of decoration that is wholly imaginative and independent of classical preconceptions.

function was not purely decorative, but principally a strengthening, functional one.

The churches of the period were almost always built with vaulted ceilings. A vault is in effect, however, a collection of arches; and since arches tend to exert an outward pressure on their supporting walls, in any vaulted building a counterthrust to this pressure is needed. The element supplying this counterthrust is the buttress, an especially typical feature in the architecture of the Middle Ages, when the difficulty was first confronted. To introduce the buttress into a Baroque construction it had to have a form compatible with that of the other members, and to avoid reference to the barbaric, 'gothic' architecture of the past. This was a problem of some importance in an age enamoured of formal consistency – and it was solved by the use of scrolls. The greatest English architect of the age, Sir Christopher Wren, unable for other reasons to use the convenient scrolls for St Paul's Cathedral, yet having somehow to provide buttresses, made the bold decision to raise the walls of the outer aisles to the height of those of the nave so that they might act as screens, with the sole purpose

The dome

▶ In their search for new forms, Baroque architects also studied structural aspects which had previously been relatively neglected. The dome illustrated, with its interlacing arches (perhaps derived from Islamic examples) and its suggestion of a 'three - dimensional theorem', carries to the extreme the quest for a complex form based on a single principle.

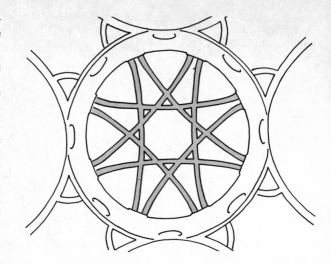

▶ As in the painting of this period, light was considered a fundamental element in architecture. The strong contrasts between brightly lit and dark areas was a principal feature of Baroque buildings and was used to create a dramatic atmosphere, as for example where a relatively dark church was illuminated at the far end from its main doorway.

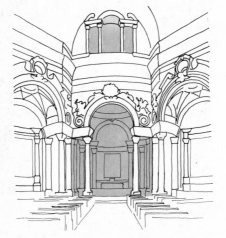

of concealing the incompatible buttresses.

Another, and decisive, consequence of the conception of a building as a single mass to be articulated was that a construction was no longer seen as the sum of individual parts – façade, ground-plan, internal walls, dome, apse, and so on – each one of which might be considered separately. As a result the traditional rules which determined the planning of these parts became less important or was completely disregarded. For example, for the architects of the Renaissance the façade of a church or

▶ Guarino Guarini's mathematical background is reflected in his work, as for example here, in the dome of S. Lorenzo, Turin. The effect is largely the result of the play of light in the dome, with the upper part brilliantly lit and the lower part in relative darkness.

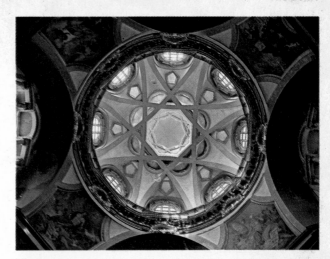

▶ Within the body of Guarini's Church of S. Lorenzo the dynamic impression conveyed by the total effect, and particularly the curve of the heavily ornamented arches, provide a sculptural and architectural combination which extends even so far as to affect the actual structure.

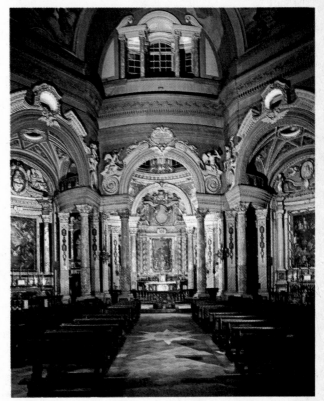

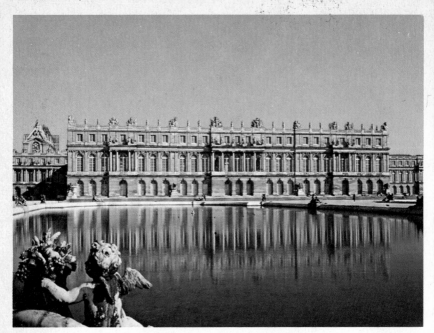

a palace had been a rectangle, or a series of rectangles each of which had corresponded to a storey of the building. For Baroque architects the façade was merely that part of the building that faced outwards, one element of a single entity. The division into storeys was generally retained, but almost always the central part of the façade was organized with reference more to what was above

◄ The garden front of the palace of Versailles, built by Jules Hardouin Mansart. Rather than as an end in itself, the simple outline of the palace, almost devoid of distinctive features, was intended as a background for the vast park, designed by the landscape architect Le Nôtre. Such parks, with wide lakes and long straight avenues stretching to the horizon, were an essential feature of French palatial design outside the cities.

and below it than to what stood on either side: in other words, it was given a vertical emphasis and thrust which was in strong contrast to the practice of horizontal division by storeys. Furthermore, in the façade the elements – columns, pilasters, cornices, or pediments – projecting from the wall surface, related in various ways to the centre, which thus came to dominate the sides. Although at first sight such a façade might seem to be divided horizontally, more careful consideration reveals that it is organized vertically, in slices, as it were. In the centre is the more massive, more important section, and the sides, as the eye recedes from it, appear less weighty. The final effect is that of a building which has been shaped according to sculptural concepts, rather than put together according to the traditional view of architecture.

A Baroque building is complex, surprising, dynamic: for its characteristic features to be fully comprehended, however, or for them to stand out prominently, it needs to catch the light in a particular way. It was this requirement that led to a further number of innovations.

It is not the light that falls on a particular point in a given building that varies, but the effect the light produces in striking one surface by contrast with another. It is obvious that the texture of a brick wall is not the same as that of a similar wall of smooth marble or of rough-hewn stone. This fact was exploited by Baroque architects for both the exteriors and the interiors of their buildings. Renaissance constructions, like many modern ones, were based on simple, elementary proportions and relationships; and their significance rested in the observer's appreciation of the harmony that united the various parts of the whole. These proportions were perceptible by looking at the fabric alone: all that was required of the light was to make them clearly visible. The ideal effect, sought in almost all the buildings of that period, was that produced by a monochrome, uniform lighting. In place of the appreciation of logic that such an effect implied, Baroque substituted the pursuit of the unexpected, of 'effect', as it would be called in the theatre. And as in the theatre, this is achieved more easily by deployment of light if the light itself is concentrated in one area while others remain in darkness or in shadow.

How can this effect be achieved in architecture? There are various possibilities: by the juxtaposition of strong

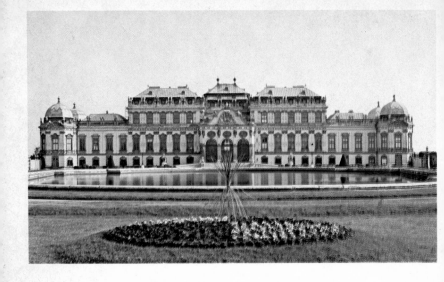

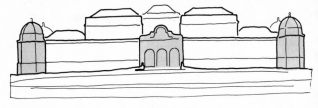

▲ ▶ In Vienna the Upper Belvedere was built by Johann Lukas von Hildebrandt for Prince Eugene of Savoy as a pavilion for festivities (the actual palace is Lower Belvedere, nearer the city). Besides the clearly marked central section of the façade, there are four small turrets added at the corners. The magnificence of the total effect is clearly Baroque, but a chastened version, with a well-distributed balance of volume.

projections and overhangs with abrupt, deep recesses; or by breaking up the surface, making it unsmooth in some way – to return, for example, to the example used earlier, by altering a marble-clad or plaster-covered wall to one of large, rough stones. Such requirements of lighting dictated a use in particular for architectonic decoration, the small-scale elements, often carved, which give a effect of movement to the surfaces of a building. It was in the Baroque period above all that such decoration ran riot. In buildings of the Renaissance it had been confined to specific areas, carefully detached from the structural forms. Now, parading the exuberance and fantasy which were its distinguishing characteristic, it invaded every angle, swarmed over every feature, especially corners and points where two surfaces met, where it had the function of concealing the join so that

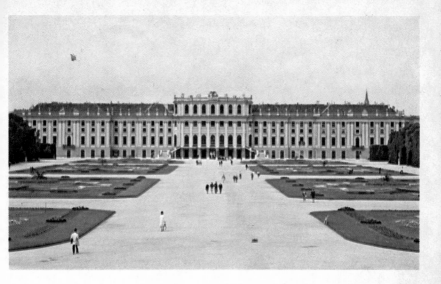

▲ ▶ Inspired by Versailles, of which this was intended as the Austrian version, the Viennese palace of Schönbrunn, by Johann Bernhard Fischer von Erlach, reveals an outstanding capacity for organization. The façade displays the Baroque emphasis on the centre and makes clear the relative importance of individual sections. Furthermore, the use of the Colossal order, which used columns rising not one but three storeys high, provides a dimension more in keeping with the total mass of the building.

the surfaces of the building appeared to continue uninterrupted.

To the five traditional orders of architecture – Tuscan, Doric, Ionic, Corinthian, and Composite, each of which had particular forms and proportions for its supporting members, the columns and pilasters, and for the vertical linking members, or entablature – was added the 'Undulating' order. Another new and popular variant was the 'Colossal order', with columns running up through two or three storeys. The details, too, of the traditional orders became enriched, complicated, modified: entablatures had stronger overhangs and more pronounced re-entrants, and details throughout sometimes attained an almost capricious appearance. Borromini, for instance, in using the Corinthian order, took its most characteristic feature, the curls, or volutes, which sprout

Use of towers

▶ The design for a church in which a central dome was flanked by two towers, already employed in Italy, was particularly successful in Austria and other German-speaking countries, where it became almost the inevitable scheme. In Fischer von Erlach's Karlskirche in Vienna, the ingenious novelty was added of the two columns, modelled on Trajan's column in Rome, positioned between the centre section and the two low towers.

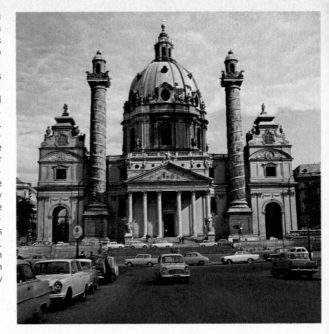

▼ The towers on either side of the church have no functional purpose, the true front of the church being that which is seen between the two columns; but their presence transforms a centralized scheme, dominated by the dome, into a pyramidal assemblage.

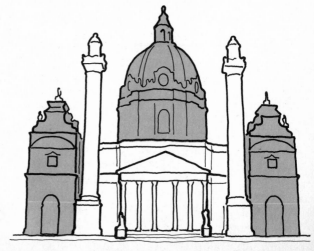

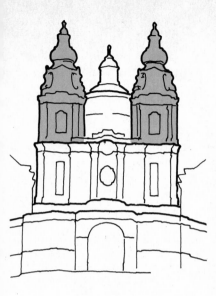

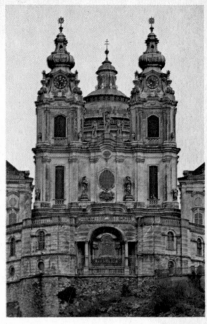

▲ Perhaps the most outstanding feature of Baroque is that it is second only to Gothic as a truly popular European style in the sense that it could be used freely and to excellent effect by a very large number of architects. In Jakob Prandtauer's abbey at Melk, in Austria, the design of the façade is again based on lateral towers, which are higher and closer together than is customary.

from among the acanthus leaves at the top of the capital, and inverted them.

The arches connecting one column or one pilaster to the next became no longer restricted, as in the Renaissance, to a semicircle but were often elliptical or oval. Above all they took the form, unique to the Baroque, of a double curve – describing a curve, that is, not only when seen from in front but also when seen from above. Sometimes arches were interrupted in form, with sections of straight lines inserted into the curve. This characteristic feature was also used in pediments – the decorative element above a door, a window, or a whole building. The canonical shape of a pediment, which is to say that fixed by classical norms, had been either triangular or semicircular. In the Baroque period, however, they were sometimes open – as though they had been split or interrupted at the top – or combining curved and straight lines; or fantastic, as for example in Guarino Guarini's plan for Palazzo Carignano, where they appeared around doors and windows like draperies rolled back.

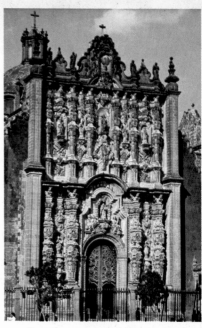

▲ In the New World, the Baroque style from the Iberian peninsula encountered the decorative traditions of the indigenous peoples, resulting in buildings that were not merely ornate but encrusted with embellishments as if they were the richly chased work of silversmiths — hence their description as Plateresque ('plata' means silver). Lorenzo Rodriguez's lavishly decorated Sanctuary, built in 1755 beside the cathedral in Mexico City, is a characteristic example.

Windows too were often far removed from classical forms: to the rectangular or square shapes, sometimes with rounded tops, which were typical of the Renaissance were added shapes including ovals or squares topped by a segment of a circle, or rectangles beneath little oval windows.

Other details, on entablatures, doors, and keystones of arches and at corners – everywhere – included volutes; stucco figures; huge, complex, and majestic scrolls; and any number of fantastic and grotesque shapes. One form of decoration not characteristic so much as striking was the use of the tower. Sometimes a single one, sometimes pairs of them, but always complex and highly decorated, were erected on the façade, and sometimes on the dome, of churches; and in some countries, in particular Austria, Germany, and Spain, this arrangement was used often enough to become in effect the norm.

These, briefly then, were the most obvious and frequently used motifs of Baroque architecture. It must be remembered however that each individual work created its own balance between its various features; and also that each country developed these components in dif-

▶ Spanish Baroque was as decorated and unsophisticated as its French counterpart was sober and imposing. This Spanish example by Fernando Casas y Novoa at Santiago de Compostela, in the form of the church by the same name, is late, belonging to the eighteenth century, but its forest of spires, its pinnacles, statues, and layers of decoration are entirely representative.

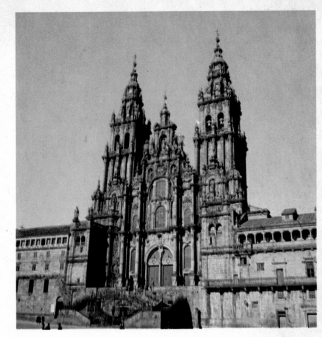

▶ Baroque art found individual expression — often differing widely — in every country. The Spanish version was one of the most highly decorative. The basic designs were not in themselves very different from those found in other countries, especially with regard to church façades, which are often flanked by two towers. But both sculptural and architectural adornments were used profusely, and constitute the distinctive feature of both Spanish and Portuguese Baroque architecture.

Town-planning

▶ Before St Peter's the impression is spectacular, solemn, and inviting, as though the two immense stone arms were a visible symbol of the ecumenical mission of the Catholic Church to embrace the whole world. It is not without significance that Baroque functioned partly as the architecture of the Counter-Reformation.

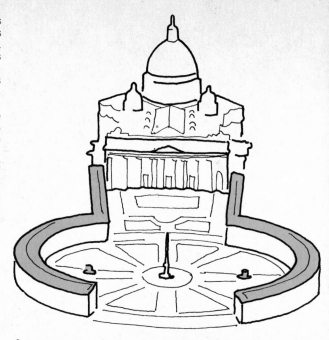

▶ Baroque architecture was not only concerned with buildings, but extended its scope also to streets, squares, and gardens: in other words to what is now called town-planning. The piazza of St Peter's, in Rome, designed by Gian Lorenzo Bernini, is the best-known and most exhilarating example of this aspect of Baroque. It consists of a huge oval colonnade, linked to the church by two slanting wings.

ferent ways; and an understanding of these regional and national differences is essential to a proper understanding of the Baroque as a whole.

Italy, the cradle of Baroque, produced in addition to a proportionate number of good professional architects a quartet who rate as excellent: Gian Lorenzo Bernini, Borromini, Pietro da Cortona, and Guarino Guarini. The work of each was unmistakably Baroque, but each of them had, as it were, a different accent. Bernini and, to a lesser extent, Pietro da Cortona, represented the courtly Baroque, majestic, and exuberant but never outrageously so, which was successful principally in the Italian peninsula. This style possessed, at their most typical, all the features of Baroque described above, and conveyed an air of grandeur and dignity that rendered it a classic of its kind. Borromini's designs were quite different, far more restless and extravagant, intellectual and original. Each of Bernini's architectural works, meanwhile, was characterized by some ingenious idea which provided the starting point: for example the great ellipse of the piazza in front of St Peter's in Rome, or the little round portico on the front of S. Andrea al

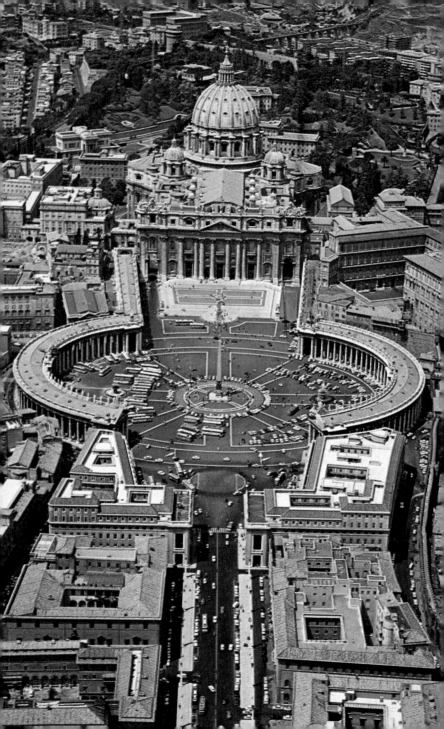

▶ The fusion of different art-forms was typical of the Baroque age. In many examples, sculpture was given a role in town-planning. This monumental fountain occupies the centre of the great piazza, serving as the focal point. The upper part consists of an architectural motif, the Egyptian obelisk; and around its base is grouped an elaborate complex of structures — giant figures reclining upon rocks, with water gushing into the basin below.

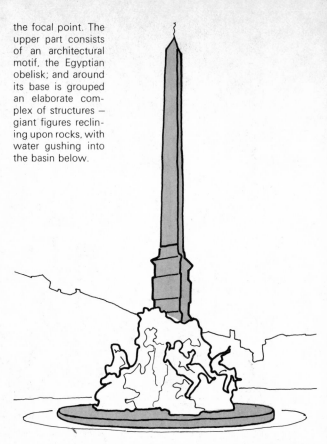

Quirinale. Typical of Borromini, on the other hand, were extremely complex ground-plans and masonry, and the deliberate contradiction of traditional detail – in the inversion of the volutes, for instance, or in entablatures that denied their traditional function by no longer resting on capitals but on a continuation above them. Many of his ideas were adopted by Guarini, with the addition of a mathematical and technical factor which was of great importance in itself – but even more because of its influence on Baroque architects outside Italy, especially in Germany.

Personal variations apart, Italian Baroque could· be said to correspond almost completely to the norms described. The same cannot be said of France, which nevertheless produced during the Baroque period a

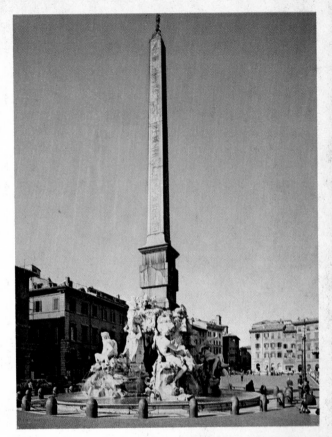

▶ ▼ The Four Rivers Fountain in the Piazza Navona in Rome was the work of Gian Lorenzo Bernini and various assistants. Its base includes the figures of the Rivers. As a combination of architecture, sculpture and town-planning, such a work expresses a key theme in Baroque art. It is not, as in earlier periods, dependent upon or attached to some other structure but stands in isolation, as a monument, and its value is enhanced by its relation to the buildings and spaces around it.

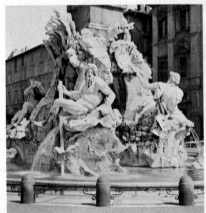

The staircase

▼ Above all, loving movement and drama, the Baroque age was one of immense theatricality. The great staircases built in the palaces of the time particularly emphasize the contemporary taste for complicated schemes and impressive and dynamic spectacle.

succession of excellent architects, even more numerous than in Italy: Salomon de Brosse, François Mansart, Louis Le Vau, Jacques Lemercier, and, greatest of them all, Jules Hardouin Mansart. But in France personality was less significant in its effects then the 'school' to which architects could be said to belong. The attempt of the French court to introduce Italian Baroque into France, by summoning Bernini in 1665 to Paris and commissioning him to design the reconstruction of the royal palace – the Louvre – was doomed from the outset. As a critic rightly observed, there was in question a radical difference of temperament. To the French, Italian exuberance verged on the indecorous, if not wilfulness and bad taste. Rather than as artists, French architects considered themselves professional men, dedicated to the service and the glorification of their king. At the court of the Roi Soleil a Baroque style was developed which was more restrained than the Italian: ground-plans were less complex, and façades more severe, with greater respect for the details and proportions of the traditional architectural orders, and violent effects and flagrant caprices were eschewed. The textbook example and greatest

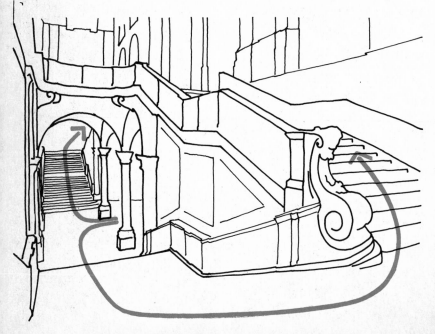

▼ The staircase, in the Baroque period, became one of a building's most important features. Many different types were evolved, including the Imperial staircase, consisting of a single flight dividing at the first landing into two lateral flights, and this particular example by Filippo Juvarra in the Palazzo Madama which, from a single starting point, leads in two different directions, turning back on itself to be re-united above the point of entry.

achievement of French Baroque was the château of Versailles, the royal palace built for Louis XIV outside Paris: a huge U-shaped mass with two long wings, disturbed hardly at all by the small, low arcades on the main façade facing the gardens.

It was not in architecture, however, that the great glory of French Baroque was to be found, but in the art of landscape gardening. Until the era of the Baroque, gardens had been of the 'Italian' type, small parks with plants and flower-beds laid out in geometrical schemes. André Le Nôtre, the brilliant landscape architect who created the new, perspective, form of garden, supplanted these by the 'French' garden, of which the park at Versailles was to become both prototype and masterpiece. In the centre stood the palace; on one side was the approach drive, the gates, the wide gravelled area for carriages; and on the other were lawns and parterres, or flower-beds in geometrical shapes, fountains, canals and broad expanses of water, and, beyond all this, the dark line of woods pierced by long, wide, straight avenues which were linked by circular clearings.

The imposing and austere architecture created in

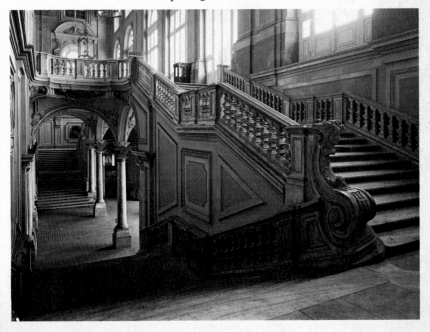

▲ A widespread feature of Baroque palaces was the salon, painted with landscapes and architectural scenes which seemed to extend to infinity the building itself. This popular approach produced slightly different results from one country to another, but the common expressive element was always a close association of painting and architecture. In such interiors, the actual building is little more than a box, enriched by illusionist devices and painted scenes.

France, with its balance between Baroque tendencies and classical traditions, was gradually to become the cultural model for progressive Europe. When Sir Christopher Wren, in the second half of the seventeenth century, decided he should bring his own ideas up to date, it was not to Italy that he went, as had been the custom until then, but to Paris. The Baroque architecture of Belgium and the Netherlands likewise bears the mark of French inspiration.

Closer to the Italian model was the Baroque of the northern side of the Alps, in Austria and Germany. This was the case, however, only in a restricted sense. Baroque influence came relatively late to the German states, which in the first half of the seventeenth century had been devastated by the Thirty Years' War. Once acclimatized, however, it underwent a remarkable growth both in quantity and quality. The great architects of the period practised at a relatively late time, at the end of the seventeenth and the beginning of the eighteenth centuries; they were, however, numerous, exceptionally accomplished, and blessed with enthusiastic patronage from the several royal, ducal, and episcopal courts of Germany. All visited Rome, and were trained in the

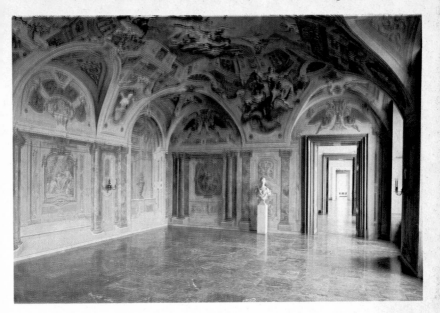

▲ The predilection for the fusion of various forms of art, the love of artifice, the attempt to suggest boundless space: these were all Baroque characteristics which found excellent scope for expression in the painted decoration of interiors. The painting might be illusionist, as here, in the Belvedere Palace, in Vienna, conveying more or less perfectly the impression of actuality, or more obviously decorative (a trend that was to be developed in *rocaille*, or Rococo, as a form of ornamentation almost entirely abstract).

Italian tradition: Johann Bernhard Fischer von Erlach, the most famous and perhaps the greatest of them; Johann Lukas von Hildebrandt; and Johann Balthasar Neumann, his probably more gifted pupil; to these must be added Matthäus Pöppelmann, and François de Cuvilliés – a Frenchman, but whose activity was almost entirely confined to Germany.

The style of Baroque created by these men was to spread to Poland, the Baltic states, and eventually to Russia. It had considerable affinity with Italian Baroque, with the addition of an even greater tendency to exuberant decoration, especially of the interior; it also differed from Italian forms by its avoidance of sharp contrasts of light and darkness in favour of a more diffused and serene luminosity. Two features also presaged the 'Rococo' style that was to succeed it, a style that found its widest application in these countries and was sometimes the work of the same architects, for example Pöppelmann, Neumann, and Cuvilliés. In the two main forms of construction, churches and palaces, the Baroque of the German-speaking countries adhered fairly consistently to a few basic designs. On churches the device of two lateral towers with which Borromini had experimented

The gallery

▼ The gallery was a characteristic Baroque architectural form — a wide, covered corridor giving independent access to the rooms which opened on to it and often transformed into a particularly elegant and imposing part of the building. Generally, it had a vaulted ceiling, and the side which did not lead to rooms looked out to the exterior.

was adopted systematically. Sometimes this was taken to the point of upsetting the general layout, as Fischer von Erlach did in Vienna on his Karlskirche. On this, a centrally planned building, in order to include the towers he added them as free-standing, empty structures on either side of the main body of the church. The whole edifice exemplifies a theatrical conception in the grand style, its form emphasized by two columns, reminiscent of Trajan's Column in Rome, which stand beside the towers. In palace design, meanwhile, the model was Versailles; but Germanic architects generally showed themselves able to surpass this example in the articulation of large masses of masonry, accentuating the central section of the building, and sometimes the lateral sections likewise.

At the same time that its influence spread north of the Alps, Italian Baroque also asserted itself in Spain and Portugal. In these countries there was no obstacle to its success, but here too an entirely individual style developed. Its salient, indeed its only particular, characteristic was a profusion of decoration. Whatever the form of a

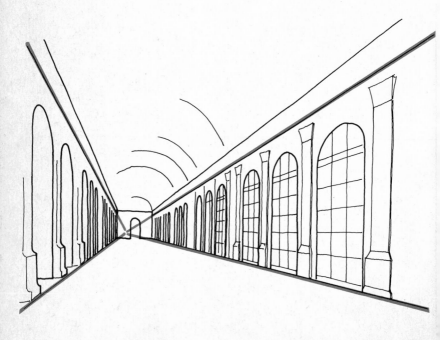

▼ The gallery was not only a functional area but, originally at least, a show-place, as in the great creation by Jules Hardouin Mansart, the Galerie des Glaces at Versailles. Galleries were often employed to display paintings and other works of art – hence the use of the word to denote such collections.

building it appeared merely to be a pretext for the ornamentation encrusting it. Many factors contributed to this result, chief among which were the Moorish tradition, still alive in the Iberian peninsula, and the influences of the pre-Columbian art of America, with its fantastic decorative vocabulary. This particular style, known as 'churrigueresque' from the family name, Churriguera, of a dynasty of Spanish architects who were particularly closely associated with it, dominated Spain and Portugal for two centuries and passed into their South American colonies, where the decorative aspect was, if possible, intensified to a frenzy of ornamentation. Its value is perhaps debatable, but as a style it is certainly recognizable, in its subordination of everything to decoration.

Going beyond the appearance of individual buildings, a number of more general themes were also typical of the Baroque style of architecture. The first was the way in which Baroque architects were the first to confront the task of town-planning practically rather than in theory. Principally, they dealt with it in terms of the circus and

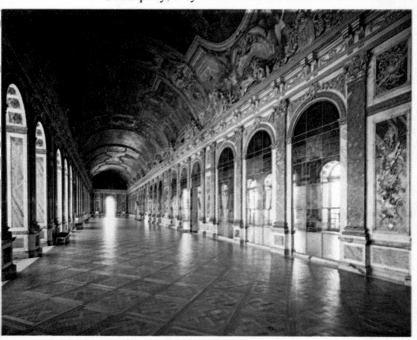

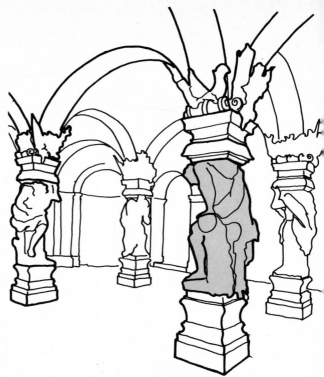

▶ The use of sculptured figures, both male (telamons) and female (caryatids), to support a roof is an ancient practice, but it found particular favour in the Baroque period, catering as it did to the taste for fantastic, surprising, or obviously absurd effects.

the straight road. Into the fabric of the city they cut circuses, each dominated by some structure, a church, a palace, a fountain, and then linked these points with a network of long, straight avenues aimed, so to speak, at these structures. It was not a perfect solution, but it was ingenious for the time. Indeed, for the first time a system was devised for planning, or replanning, a city, making it more beautiful, more theatrical, and above all more comprehensible because subordinate to a rule. Through the use of such schemes for town-planning, which parallel those of the French type of garden, conceived on the same principle, there evolved the great monumental fountains, in which architecture, sculpture, and water combined to form an ideal centrepiece and to express the Baroque feeling for scenography and movement. It was no chance that Rome, the city which more than any other was planned according to the new norms of the seven-

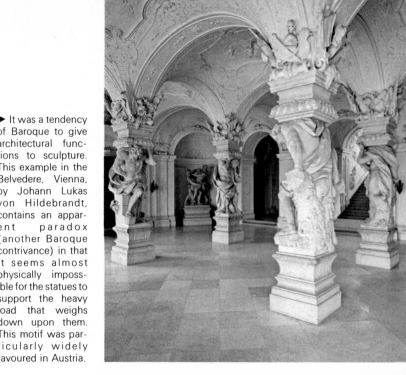

▶ It was a tendency of Baroque to give architectural functions to sculpture. This example in the Belvedere, Vienna, by Johann Lukas von Hildebrandt, contains an apparent paradox (another Baroque contrivance) in that it seems almost physically impossible for the statues to support the heavy load that weighs down upon them. This motif was particularly widely favoured in Austria.

teenth century, is *par excellence* a city of fountains.

Two other characteristic themes treated by Baroque architects concerned domestic interior structures: the complex great staircases that began to appear in all aristocratic buildings from the seventeenth century onwards, sometimes becoming the dominating feature; and the gallery, in origin a wide, decorated corridor, and another showpiece, of which the Galerie des Glaces at Versailles is an outstanding example. Often the gallery, like many other rooms in the Baroque period, would be painted with illusionist scenes, conveying a realistic extension in every direction of the gallery itself which would often actually intrude upon the architecture, reducing it to a secondary role. This is another example of the Baroque taste for the overlapping of art forms, and the point at which architecture yields to painting.

Painting

It is appropriate to begin an account of Baroque painting with its favourite genre and characteristic function: the illusionist decoration of the walls of an interior. Obviously the idea of using a wall to display a painted scene was as old as art; what was new, or almost new, was the use made of this technique by Baroque artists. On the walls, and more especially on the ceilings, of churches and palaces they painted vast, busy scenes, which tend to produce upon the spectator the impression that the walls or ceiling no longer exist, or at least that they open out in an exciting way.

This, too, was not essentially new: such experiments

▶ The exploitation of perspective was especially fashionable in the Baroque period. This example, by Andrea Pozzo, represents the glorification of St Ignatius, painted on the upper reaches of the Church of S. Ignazio, in Rome. Illusionist paintings based on perspective were used to cover the vaults and ceilings of churches and palaces with vast, bold, architectural subjects, soaring figures, and infinite spaces. Almost all the distinctive Baroque features are to be found in such paintings: grandeur, movement, exuberance, technical skill, and the attempt to break free from convention in order that infinity might be suggested, using foreshortening.

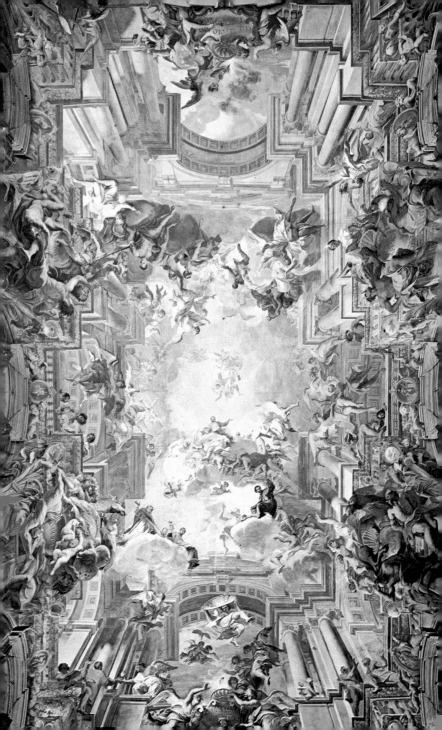

Illusionist painting

▲ The tradition of illusionist painting closely integrated with architecture was one of the salient and longest-lived characteristics of Baroque.

had already been made during the Renaissance. In the Baroque period, however, it became almost an absolute rule, combining as it did all the aesthetic features of the time: grandeur, theatricality, movement, the representation of infinity, and in addition a technical skill that appears almost superhuman. It showed that tendency to combine various forms of art for a unified effect which was the most distinctive characteristic of the age.

Such illusionist paintings varied greatly in the stories they told – lives of saints, histories of dynasties, myths, or tales of heroes – but they were consistent in the components they deployed: architectural glories standing out against the sky; soaring angels and saints; figures in swift motion, their garments billowing out in the wind; all depicted with bold foreshortening – the perspective effect of looking upwards from below or conversely downwards from above, which makes the figures appear shorter. Such was the vitality of the genre that it continued not only throughout the seventeenth century but well into the eighteenth, invading the limits of time generally considered to demarcate the succeeding Rococo movement.

Naturally, painting was not confined to the walls of buildings. There was also, and indeed especially, a tradition of painting on canvas, and as with architecture the characteristics of the various national schools

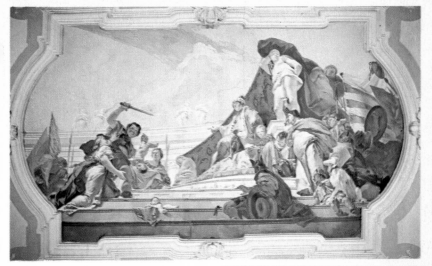

▲ ▼ ▶ Giambattista Tiepolo's *Judgment of Solomon*, in the Archiepiscopal Palace, Udine, was executed well into the eighteenth century. It was a crowning achievement in the field of using perspective to create illusion. Here, the artist adds to the genre a new technique, known as centrifugal composition, in which the figures are arranged along the sides of the paintings while the centre lies open to the widest prospect of sky.

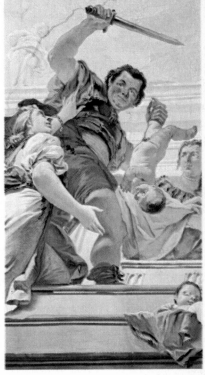

▲ =Light, or rather the representation of the effects created by it, was a distinguishing and dominant feature of Baroque painting. The first to make decisive studies along these lines was Caravaggio, whose work influenced, to some extent, all the art produced during the period. In his paintings, the whole scene is not uniformly lit but only some areas, those important to the composition.

differed widely. They had one concern in common, however: the study of light and its effects. In spite of the great divergences between the work of various artists in the Baroque period – divergences so great that many critics are not prepared to designate their work by a single common adjective – the thematic use of light and shade in constructing any significant work was, to a greater or lesser degree, common to them all, to the extent of being the unifying pictorial motif of the age.

The impulse towards adoption of this idiom came from Italy, indeed from a single Italian artist, Michelangelo Merisi, known as Caravaggio from the name of the small town where he was born. Although his work has been more attacked by some critics than appreciated, there is no doubt that he marked the beginning of a new epoch. At the time of Caravaggio, painting had fully attained the objectives that it had been set two centuries before – namely, the perfect representation of nature in all its

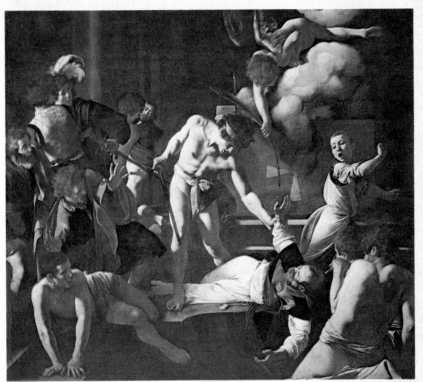

▲ In Caravaggio's paintings generally, as here, in his *Martyrdom of St Matthew,* areas of dark, almost i m p e n e t r a b l e shadow are juxtaposed with areas of bright light and these strong contrasts make his figures stand out in high relief. To this fundamental technique is added the presentation of reality in its cruder, more harsh aspects.

manifestations. A new line of investigation was required, one congenial to the age; and this Caravaggio supplied. His paintings showed sturdy peasants, innkeepers, and gamblers; and though they might sometimes be dressed as saints, apostles, and fathers of the Church they represented reality in its most crude and harsh aspect. This was in itself a break with the Renaissance, with its aristocratic figures and idealized surroundings. The most important aspect of Baroque painting was not however what was represented but how it was represented. The painting was not lit uniformly but in patches; details struck by bright, intense light alternated with areas of dark shadow. If in the final analysis a Renaissance painting was coloured drawing with overall lighting, a canvas by Caravaggio was a leopard's skin of strong light and deep, intense shadow, in which the highlights are symbolic; that is, they indicated the important elements of the composition. It was a dramatic, violent, tormented

Rubens

▼ Where Caravaggio represented the dramatic side of Baroque, Rubens typified the opulent and grandiose. His nudes have powerful muscles and broad gestures and his canvasses are characterized by the physical exuberance of his figures.

style of painting, eminently suited to an age of strong aesthetic contrasts, as the Baroque period was.

Yet the essential aspects of Baroque painting developed very little in the country of Caravaggio's origin. His inheritance was harvested instead in Spain, and in Flanders and Holland. There, unlike architecture, painting had developed flourishing local schools that so far from being backwaters were well in the van of artistic exploration. Flemish painters had created a genre of painting concerned with the faithful representation of domestic life and everyday reality which had no parallels

▼ Rubens studied in Italy for eight years and was familiar with the work of Italian painters. He admired the Venetians most of all, and this is evident in his own painting, for example *Rape of the Daughters of Leucippus*, in which colour was all-important.

in Italy – where there was indeed no demand for such pictures. It was the Flemish painters who had exported the technique of oil painting, formerly unknown to the artists of the early Italian Renaissance. Now they were quick to fuse their own tradition with that arriving from Italy – a marriage which was to produce works among the greatest achievements in the history of art.

This development had different results in Flanders and the Netherlands respectively, and in each case was associated with the two profoundly different personalities of either Rubens or Rembrandt.

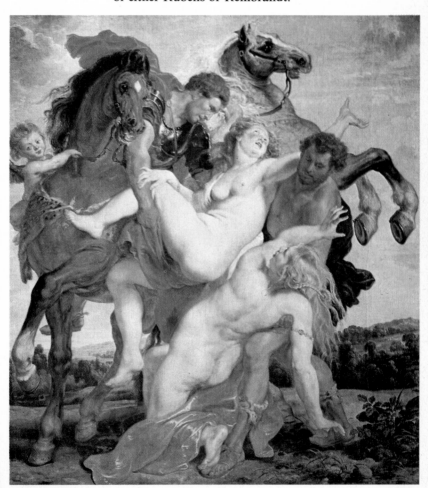

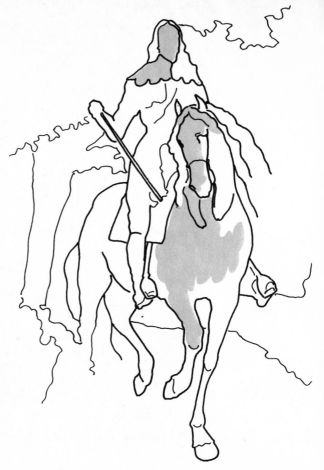

▶ Anthony Van Dyke was a pupil of Rubens and absorbed many of his stylistic traits; but he specialized in portraits. In the context of Baroque painting, his works are distinguished by the relative restraint of their composition. More typical of the period, however, is the way in which light and shadow were used to give importance to the most significant passages, in this case the sitter's face and the white coat of the horse.

In Rubens' work the style was vigorous, confident, sensual, decorative, theatrical, energetically magnificent. It is not without significance that when Peter Paul Rubens, the promising painter from Antwerp, arrived to study in Italy – where he remained for eight years – he devoted most attention to the Venetians, the most colourful and decorative Italian school. When he returned to his native city he opened a workshop where he was soon employing two hundred assistants, many of whom were outstanding painters, each with his own speciality: the painting of animals, of fabrics, of still life, and so on. He himself specialized in the human body,

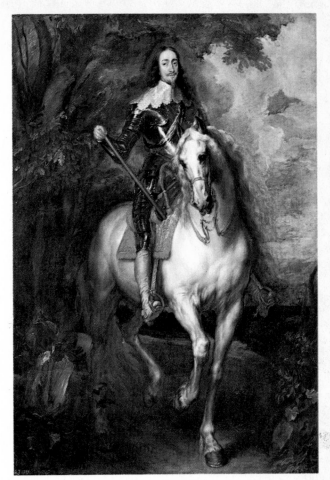

► Although the composition of this Van Dyke portrait of Charles I almost seems to belong to the Renaissance, what makes it of its age is the use of colour and, above all, the way in which the subject is lit. This reveals another characteristic of Van Dyke's work, namely its courtly, urbane, aristocratic elegance.

which he depicted with an abundance of rosy flesh, with broad, strong gestures, a continuous play of curves, each one drawing the eye to another, the sum of which determined the general scheme of the painting – as a lozenge, a circle, an S, and so on. These robust figures, who move as expansively as though they were on a stage, are the immediately recognizable feature of his art, an art which is joyous, robust, and almost unbelievably prolific.

All Flemish painting was influenced by this prodigious artistic patriarch. None of its practitioners, however, came near rivalling the master: some devoted themselves to one aspect of his work, others to another. The most

▶ Rembrandt was a painter of such individuality and greatness that it is only through convention that he is labelled Baroque. In his work, however, he developed the most Baroque of all themes, the investigation of a personality or a situation by means of contrasts of light and shadow. In his *Self-portrait* as *St Paul* this device is used in a manner that is essentially Caravaggesque; but the shadows are darker while the light is less strong; and the colours, too, are more subdued.

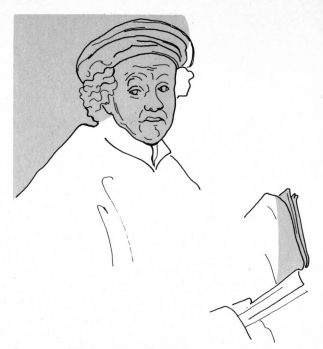

famous of Rubens' pupils for example, Anthony Van Dyck, specialized in portraits, in which he attained his greatest successes. Both in the general composition of these paintings and in the poses of their subjects he was far more restrained than his master, and his colouring was more subdued. The subject was portrayed in a moment of repose, or at least of calm; the attitude was one of dignity; the background was always mannered: an unidentified landscape, or, for single subjects, the plinth of a column. As the court painter of Charles I, Van Dyck was the founder of an English school of portrait painting.

Rubens personified the exuberant, theatrical, courtly side of Baroque art. Rembrandt, on the other hand, the greatest painter of the Netherlands, represented its tormented, dramatic, introverted aspect. He was Caravaggio's heir; and he made this inheritance the nucleus of an incomparable achievement. Rembrandt's was not an isolated phenomenon but as it were part of a collective enterprise. The United Provinces, of which Holland was one, were the northern part of the Low Countries, less developed than Flanders and they had

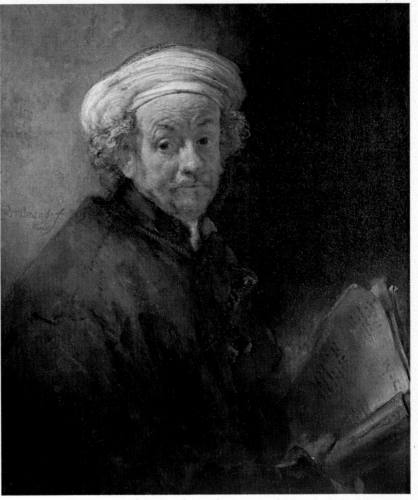

once been perhaps the 'poor relations' of the Flemings. But in the seventeenth century the nation was rich, proud, and expanding in influence. It was also addicted to painting: every sort of person indulged in appreciation of it; merchants, burghers, artisans, sailors – all knew, or prided themselves on knowing, something about it.

The paintings they wanted and which they commissioned from their artists were however different from Italian paintings, even from those of Rubens. The Dutch, being Protestants, had banished religious painting, which

▲ ▶ Franz Hals: *The Governors of St Elizabeth's Almshouses, Haarlem.* Paintings of this kind, of which Hals was the leading exponent, are typical of Dutch group portraits of the period: a background of mellow colours tending to black, a canvas with marked horizontal emphasis, and a grouping of several figures along a table, all of more or less equal importance. The light is unifromly diffused so that the faces are enhanced and illuminated by the glow reflected from the broad, white collars.

was almost the only kind known in Catholic countries. Once they had gained their independence, they expressed their contentment in the enjoyment of the good things of life: fine, solid houses; convivial company; clothes of high quality. They were, in short, bourgeois, and they wanted bourgeois paintings: scenes of everyday life to hang in ordinary houses and accordingly painted on canvasses of moderate size.

For these reasons Holland seemed the least likely country to receive a transplantation of the violent, tormented art of Caravaggio, with its striking contrasts of form. Indeed the typical Dutch painter was Frans Hals, who specialized in the subjects most in demand – individual and group portraits. The latter were characteristic of the country and the time. During the wars with Spain, many companies of volunteer soldiers had been formed – we should perhaps call them militia companies. After the Dutch victory their members had not gone their separate ways but continued to meet; and each of these companies wanted a group portrait to show their members gathered together. Usually these canvasses were of greater width than height, and showed the officers of the company grouped around a table or some other object that would serve as a pretext for a gathering of so many men. The lighting was depicted as natural, without any dramatic contrast, giving the same emphasis to each of the subjects.

Rembrandt Harmenszoon van Rijn – such was his

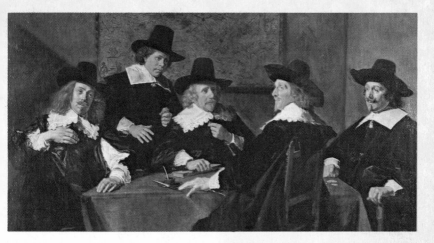

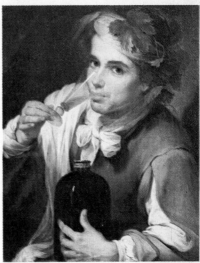

▲ Bartolomé Esteban Murillo: *Young Drinker*. In Spain, in contrast with the formality of the state in its public aspects, Baroque painting was generally rich and exuberant. It stressed important areas with light.

name in full – also painted collective portraits of this kind, but in an entirely different spirit. The most famous of these has acquired the title of *The Night Watch* because of the dark background from which its figures emerge, partially or wholly illuminated by patches of light; but it is not a night scene. It is a case of the application of the manner of Caravaggio to Dutch painting in the form of the contrast of dark shadow with areas of strong light. The traditional scheme of the group portrait is altered in

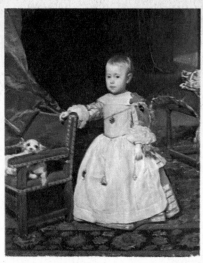

▲ The prodigious ability of Velázquez reveals him as a painter who cannot simply be labelled as Baroque. But his method of using the effects of light, not through marked contrasts but rather as a continuous gradual shifting of intensity in the different areas of the canvas, is entirely in the Baroque style. In his portrait of Prince Philip Prosper, the colour relationship between the child's garment and the dog is the most obvious of many examples.

another way, even more significant than the change of atmosphere. The officers do not all have the same importance but are presented in strictly hierarchical order. The captain of the company and his lieutenant are seen in strong light in the centre with the others around them, only their heads emerging from the shadow. Such an approach signified the beginning of an interest in the use of light to observe a single figure, or sometimes only a face.

In Rembrandt's single portraits, too, the strong contrasts of Caravaggio appear and in fact the shadows are even darker and invade almost the entire canvas. The light falls from one side of the subject, illuminates his face, dramatizes every wrinkle. Sometimes it also strikes a secondary subject – a book, a table, or other object. The rest is an area of darkness whose purpose is to throw into relief those parts that are minutely scrutinized. As a style of painting it can be called Baroque because it belongs to the seventeenth century; but in almost every other respect it has left behind the conventions of the period, preserving only the use of light in the composition to make the subject stand out.

Spanish Baroque painting also took inspiration from Caravaggio's use of light. Among the ranks of its artists it numbered several masters of genre painting, of portraiture, of religious scenes, for example Bartolomé

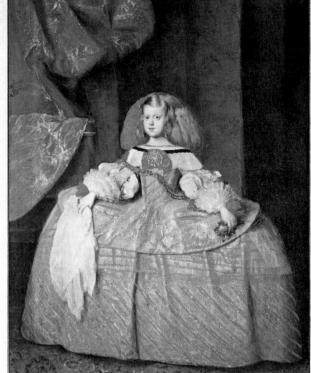

▼ ► The magnificence of the Infanta Margarita, in this portrait by Velázquez, is rendered with equal splendour by the painter, who uses not only lighting to bring out the colours of the dress but repeats and counterbalances them in the great curtain.

Esteban Murillo, and it included such outstanding interpreters of the asceticism and spirituality of Spanish culture as Francisco de Zurbarán. But in the work of Diego Rodriguez de Silva y Velázquez, it reached a summit. For Velázquez the manner of Caravaggio was only a starting-point. In his paintings light is manipulated to reconstruct an 'optical realism' by means of the effects of different tonalities: in other words, the reproduction of reality which is not faithful to the hairs of a beard or the texture of a fabric in the manner sought by the painters of the Renaissance, but to what the eye actually sees, the general impression we receive when looking at something. In Velázquez's paintings light is used as painters of two centuries earlier had used perspective, to make space tangible. Areas of light and shadow are alternated to create the illusion of a place in which the figures are not painted but actually 'are'. These figures

Still life

▶ Francisco de Zurbarán: detail from the *Portrait of Fra Gonzalo de Illescas*. In addition to sustaining traditional genres of painting, the Baroque perfected a new one, the 'still life', by which is meant the representation of arrangements of everyday objects such as flowers, fruits, books, game, etc.

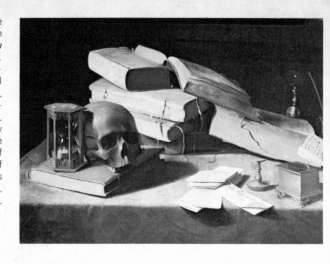

▼ The still life was a type of studio picture, that is executed indoors, in which the accurate and detailed rendering of the subject, through the use of light and shade, was crucial.

are painted with broad, supple strokes of the brush to delineate them clearly without entering upon realistic detail. It was the same technique that was to be used in the nineteenth century by the French Impressionists – a similarity that is not fortuitous: Velázquez too seemed indifferent to the content of what he was painting, to the great religious themes, for example, which had such importance for his contemporaries. Instead, his whole attention was concentrated on painting, on his craft.

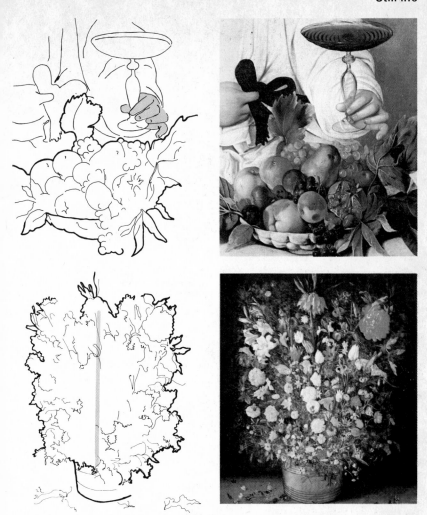

▲ (Top) Caravaggio: detail from *Bacchus*; (below) Jan Brueghel: *Still Life*. Both are exercises in tone and composition on the pretext of showing detail from everyday life.

It was in the Baroque period too that a genre of painting was developed that was to remain successful up to our own time – the 'still life', a picture offering an arrangement of flowers, of more or less inanimate objects of one kind or another, generally painted in the studio, that is to say indoors. Of course paintings of this kind had certainly been made earlier, but now they constituted a true genre, with practitioners in every country and in every school of painting. Again the

53

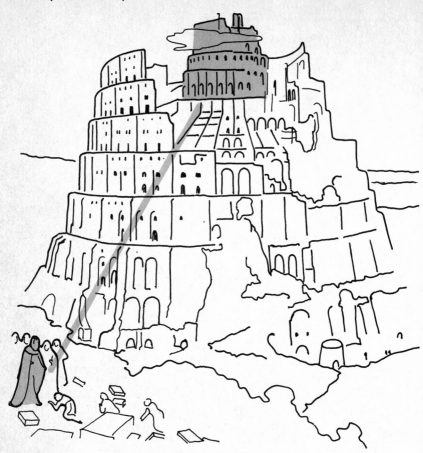

▲ The lofty and massive tower seems to bear down on the scene at its base. However, equilibrium between the two parts is re-established by the colour references between the summit of the building and the majestic figure below, thus connecting the two poles of the work.

innovator who had founded this kind of painting was Caravaggio, who indeed began his artistic career in this type of work. Not unnaturally, however, the genre reached its highest development in the Netherlands, where there was already a precursor, if not a tradition, of realistic, domestic, straightforward painting carefully attentive to the detail of everyday life, which had been produced there from as early as the fifteenth century.

Of other traditional genres of northern European painting, one must at least be mentioned, namely the large scenes of biblical or plebeian subjects, forming a vast representation, whether peasant or aristocratic, of an entire human universe. This type of painting reached

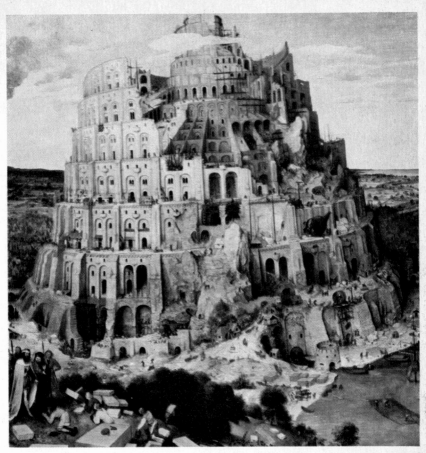

▲ Following such early examples as the elder Pieter Brueghel's *The Tower of Babel*, mythological and fantastic landscapes were highly favoured in the Baroque period, providing scope for complex, dramatic, grandiose, and far-fetched compositions.

its highest point at a time preceding almost all the painters mentioned here, in the work of followers of the great Brueghel, among them his son Pieter the Younger. It is nevertheless appropriate to any account of Baroque painting, for its grandiose, not to say epic, atmosphere, in paintings based on the juxtaposition of strong colours, energetic movement, dramatic contrast, and above all on unbridled, prodigious, exultant, and almost demonic fantasy: on all, in short, that was most Baroque.

Sculpture

The Baroque period did not lack sculptors, although few of them were outstanding – perhaps only Gian Lorenzo Bernini, who was even greater as a sculptor than as an architect. Those sculptors who did rank as the foremost in their occupation were employed with unprecedented intensity, for sculpture was perhaps the most characteristic art form of the Baroque age and was certainly the most widespread. Not only did it succeed, unlike architecture and painting, in the creation of an artistic idiom largely common to all Europe, but it affected the appearance of almost every artistic artefact produced during that period. In short, the first recognizable characteristic of Baroque sculpture is its omnipresence.

Sculptures produced in this period can be divided into two broad categories: those intended for decoration, to add the finishing touches to architecture; and sculpture in the usual sense of the word, as an item in itself.

▶ In sculpture, as in painting, Baroque artists were frequently concerned to mingle different art forms. In this work the total effect is obviously architectural, almost one of town-planning; but the principal role is given to sculpture through the line of statues on either side of the bridge, which forms a receding procession.

Architecture made use of decorative sculpture in three typical ways. The first was in the form of a horizontal line of statues or other sculptures to complete the top of a building. Again this was not a Baroque invention, but it was in the Baroque period that it became a conventional stylistic feature, a systematic method. It derived from the custom which became fashionable in the seventeenth century of surmounting a building by an 'attic'. In effect this was a low parapet concealing the sloping sides of a roof, which gave the building seen from below the appearance of ending in a horizontal line. This feature came to be almost always decorated with a row of statues regularly placed and standing out against the sky. Examples include St Peter's, Rome, whose oval colonnade was the work of Bernini himself, and the palace of Versailles, where the place of statues is taken by huge urns and friezes. From the attic or roof of a building the practice was extended to other horizontals – the walls enclosing gardens, the parapets of bridges, and so on.

Another architectural use of sculptured elements such as statues was to replace columns as supporting features, whether as caryatids (uprights in the female form) or

▼ Gian Lorenzo Bernini and assistants: statues on the Ponte S. Angelo, in Rome. The idea of a row of statues placed at regular intervals to complete an architectural complex – in this case the approach to Castel S. Angelo – certainly existed during the Renaissance but, in the Baroque period, it became a more frequent motif.

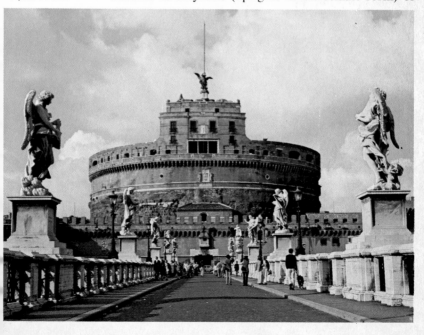

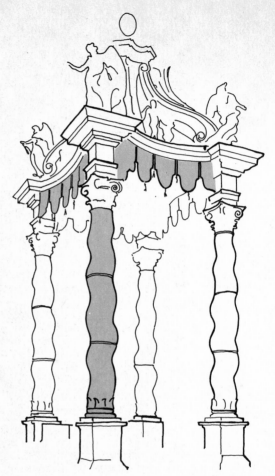

▲ ▶ As an individual item some Baroque sculpture can up to a point be considered an architectural work. A motif that was to prove extremely successful at this time was the solomonic column, twisting in a spiral, which is the dominant feature of this canopy.

telamons (those in male form). This use had a history going back to classical Greece and became a vogue especially in the Baroque of Austria and Germany.

The third and most typical use of sculpture in combination with architecture was in friezes, groupings of coats-of-arms, scrolls, trophies, and similar elements. The combination of sculpture with architecture even reached the point where sculpture seems to be, or actually becomes, architecture, as in Bernini's *baldacchino* in St Peter's, in which the roles of the two forms mingle to a degree very much in keeping with Baroque taste.

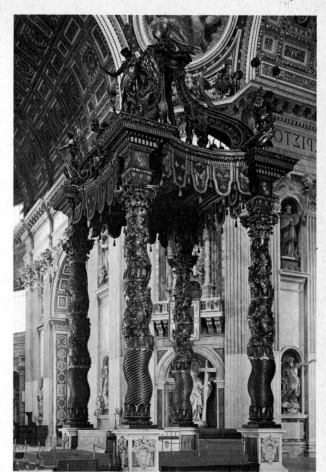

▶ Bernini's *baldacchino*, in St Peter's, Rome, is a memorial to Urban VIII. Built on a scale suited to the immense space surrounding it, this structure is of truly colossal dimensions. True to the Baroque love of artifice, it also displays tricks typical of the processional contrivances from which it derives: for instance, the great fringes are slightly disturbed in different directions as though they were moving in a breeze.

Such, then, were the ways in which sculpture was linked with architecture. The work traditionally undertaken by the sculptor in former ages, on tombs, altars, commemorative monuments and the like, continued meanwhile to be produced in the Baroque period. It generally had designs which approached, or could even be taken for, scenography, with a theatrical approach akin to stage-setting – perhaps appropriately in a period that saw the rise of melodrama and the modern theatre. Thus in a side-chapel Bernini presents the ecstasy of a saint as a theatrical event, with members of the family who

commissioned the work portrayed life-size, seated in boxes just as though they were in a theatre watching the spectacle.

The sculpture in these works had two outstanding characteristics. Firstly, it was technically perfect. The skill of the Baroque artists constituted a true virtuosity in, for example, rendering the appearance of human skin according to whether the subject was man or woman, old or young. Curls, drapery, different fabrics such as wool and silk, the texture of armour – all were precisely imitated. Such was the mastery of the sculptors over their material that in statues carved from marble it is impossible to deduce or imagine the original shape of the block. Michelangelo, epitomizing the ideals of the Renaissance, had said that a statue should give the impression of being able to roll from top to bottom of a hill without being harmed. No such thing could have been said of Baroque sculptures. They have what might be called a photographic objective – to perpetuate a movement. This involves the use of free, loose design, and also of shapes for the human form far more slender than those considered desirable by Renaissance artists.

In sculpture the other especial characteristic of the period – and the most important – was the appearance of movement. Figures are never depicted in stillness or in attitudes of repose but always in motion, and most typically at that moment of least equilibrium which is the climax of a movement, the imperceptible but dramatic moment, for example, when a vaulter is no longer rising but has not yet begun to descend and is motionless, in an attitude of potential, in mid-air. When he wished to portray Apollo in pursuit of Daphne, Bernini chose the most dramatic moment, when Daphne is transformed into a laurel tree to escape from the god: the moment of climax of the action.

It was because of the preference for movement that the outline known as the *figura serpentinata*, the serpentine figure, enjoyed such a vogue in the seventeenth century. As a way of representing the human figure it first came to the fore in the second half of the sixteenth century, the period immediately preceding the Baroque. The figure was represented in this mode in the act of performing a spiral movement, the result of swift rotation such as that of an athlete throwing the discus.

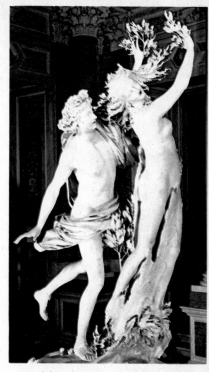

▲ If the whole of Baroque art had to be summed up in a single word, the one chosen would probably be 'movement', a quality especially evident in contemporary sculpture. In Bernini's *Apollo and Daphne*, the curves described by the bodies of the two figures harmoniously draw closer together at the base of the composition, suggesting a movement transfixed at its climax as the nymph is changed into a laurel tree to escape the pursuing god.

Sometimes the composition became exaggerated in a way suggestive more of agitation than of motion. The artist was sometimes so enamoured of the effects he was producing, of his technical skill, that he lost sight of the harmony of the total composition. Such an effect was always likely, however, when from the work of masters we pass on to that of the journeymen. One merit of the Baroque was that it created conditions in which second-rate work could be assimilated into the execution of complex works of greater artistic value: the great fountains inhabited by bearded figures, satyrs, nymphs, dolphins, and assorted monsters which adorned the piazzas and the avenues of Baroque cities and gardens, the decoration of the great staircases in the palaces of the time, down to the stucco work and other profuse ornamentation of galleries, salons, churches, in every sort of interior. In these works the overall impression created was sometimes merely orgiastic; generally, however, the Baroque style achieved an effect of triumph.

Glossary

Acanthus: a Mediterranean thistle, the leaf of which was represented in a stylized form on capitals of the Corinthian and Composite orders. *See* Order.

Attic: an architectural structure placed around a roof so that the roof is not visible from below, so called because it was frequently used in Attica. Sometimes the word is also used to denote the top storey of a building, which may be lower in height than the others.

Balustrade: a typical Baroque parapet formed by low columns or pillars which supported a handrail or coping. It was frequently used for staircases, balconies, and, in church architecture, to separate chapels from the aisles of a church and the areas accessible to the congregation from those reserved for the clergy.

Caryatid: a column shaped like a woman. The male equivalent is a telemon.

Chiaroscuro: in painting, the use of contrasts of light and shade.

Composite: one of the architectural orders elaborated by the Romans and used again during the Renaissance and Baroque periods. It was particularly rich in decoration, especially on the capitals, which combined the acanthus leaves characteristic of the Corinthian with the volutes of the Ionic order.

Corinthian: one of the Greek architectural orders, used widely by the Romans and during the Renaissance and Baroque periods. It was mainly distinguished by the acanthus-leaf decoration of its capitals.

Cornice: in an order, usually the upper and most projecting part of the entablature. The term has also come to mean the moulding above a painted panel, a door, or a window, and it is often used to designate any decorative horizontal summit to a building.

Entablature: the horizontal elements above the columns of a given order, comprising architrave, frieze, and cornice.

Foreshortening: the representation of a figure placed not in a vertical or horizontal plane relative to the observer but in an oblique plane so that certain parts will appear nearer and others further away. It is so called because the figure otherwise appears to be shorter than in a normal representation.

Ionic: an architectural order chiefly characterized by its volutes, like a scroll of paper rolled at either end, which decorate the capitals.

Order: an architectural system characteristic of classical art and its derivatives, consisting of given elements.

Pediment: originally the upper part of a wall, triangular in shape, between the sloping sides of a pitched roof. The term subsequently came to mean any element that surmounted the wall of a building, irrespective of shape.

Pilaster: a shallow pier attached to the wall of a building, usually conforming to the decoration of one of the orders. Strictly speaking its function is ornamental rather than weight-bearing.

Plateresque: a heavily ornamented style of Baroque architecture popular in Spain; literally 'silver-work'.

Portico: a roofed area, open or partly enclosed, and often with columns and a pediment, forming the entrance and central feature in the façade of a building.

Rococo: style of architecture and related art forms, considered the last phase of Baroque. It was distinguished by features including graceful shell-like curves. The term derives from *rocaille*, shell.

Scroll: a decorative feature with an accentuated curve or spiral form. The term is sometimes used to denote a volute. *See* Volute.

Still life: a painting of smallish inanimate objects, for example flowers or fruit.

Trompe l'oeil: a term, literally meaning 'deceive the eye', used to designate a type of painting in which every contrivance is used to convey the illusion of reality.

Telamon: *see* Caryatid

Volute: a scroll or spiral decoration forming part of the capitals of the Ionic and Composite orders.

Bibliography

Bazin, Germain, *The Baroque*, Thames and Hudson, 1968. A good general survey.

Blunt, Anthony, *Art and Architecture in France, 1500-1700*, Penguin Books, 1973.

Bottineau, Yves, *Iberian-American Baroque*, Macdonald, 1971.

Charpentrat, Pierre, *Baroque*, Oldbourne, 1967. Recommended for its pictures.

Clark, Kenneth, *Rembrandt*, Murray, 1978.

Hempel, Eberhard, *Baroque Art and Architecture in Central Europe*, Penguin Books, 1963. The standard work.

Lees-Milne, James, *Baroque in Italy*, Batsford, 1959.

Lees-Milne, James, *Baroque in Spain and Portugal*, Batsford, 1960.

Millon, Henry A., *Baroque and Rococo Architecture*, Studio Vista, 1968.

Wittkower, Rudolf, *Art and Architecture in Italy, 1600-1750*, Penguin Books, 1958. A standard work and very readable.

Wittkower, Rudolf, *Bernini*, Phaidon, 1955.

Wölfflin, Heinrich, *Renaissance and Baroque*, Fontana, 1964. Written eighty years ago but still valuable.

Sources

Alte Pinakothek, Munich: 43; Frans Hals Museum, Haarlem: 49; Galleria Borghese, Rome: 61; Hieronymite Monastery, Guadalupe: 52; Kunsthistorisches Museum, Vienna: 50, 51, 55; National Gallery, London: 49; Prado, Madrid: 45; Rijksmuseum, Amsterdam: 47; S. Luigi dei Francesci, Rome: 41; Uffizi, Florence: 53 (above and below)

Index

Index

Photocredits